# Crazy Patchwork

Using Water-Soluble Stabiliser

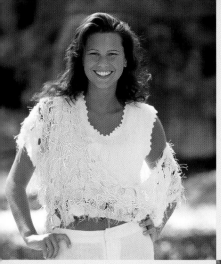

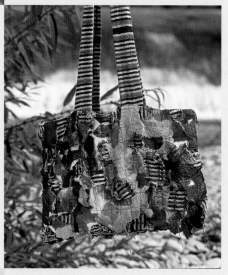

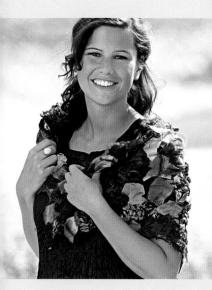

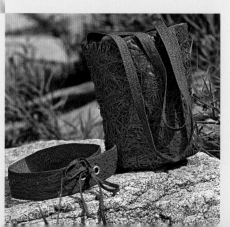

Jeannette Knake

# Crazy Patchwork

Using Water-Soluble Stabiliser

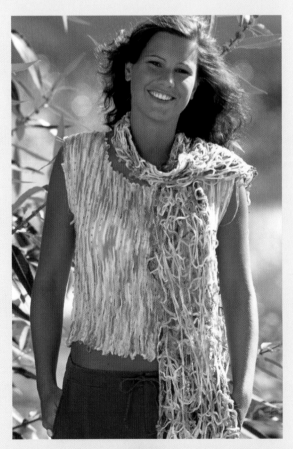

SEARCH PRESS

*Jeannette Knake* *has been working in the creative field for many years. Through her Crazy Patchwork, Crazy Wool and Crazy Felt techniques, she brings a new, fresh and modern approach to the subject of handicrafts.*

# FOREWORD

## Dear Readers,

*Crazy Patchwork is all about sewing using small pieces of fabric of the same size. Endless imaginative possibilities can turn garments and accessories into virtually designer pieces. Yet the items are easy to make and are therefore suitable for beginners as well as experienced needlecrafters, as the seams and hems do not need to be finished off. When sewing the seams, you need to keep them an equal distance from the edge of the fabric. It does not matter if the lines are not quite straight, as they will not show against the multi-coloured background. Crazy Patchwork combines special-effect yarns and leftover bits of wool and fabric with craft materials such*

*as raffia and leather. You can also take old scarves and shawls and turn them into new and fashionable items. Create your own style too by using self-dyed silk.*

*In this book, I present a wide variety of items in designs that are easy to make and will capture the hearts of young and old alike. By making the sewing easy, I have left more scope for you to develop your own designs.*

*I hope that you will get a lot of pleasure from using the different materials, as well much fun and success from creating your new own fashionable garments and accessories.*

*Jeannette Knake*

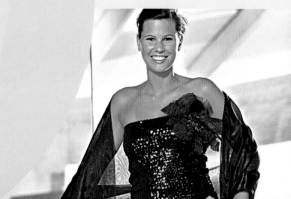

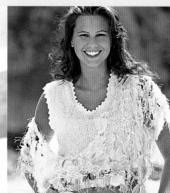

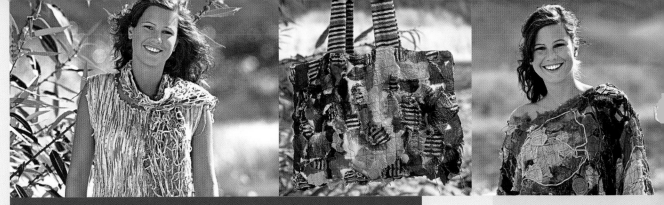

# CONTENTS

◆ = for beginners      ◆◆ = previous experience required      ◆◆◆ = for the advanced

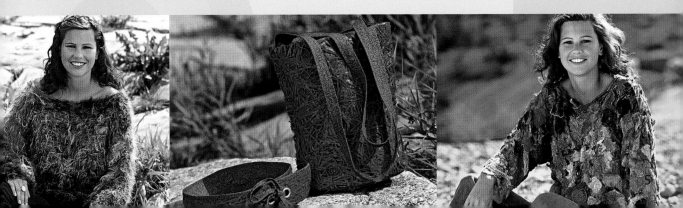

# Types of materials

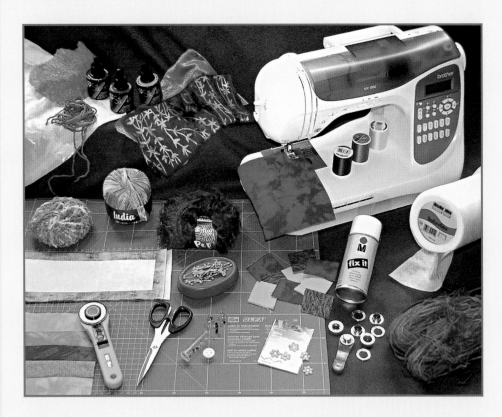

Fabric and yarn designs change during the year. That's why the range on offer in the shops varies and they will always offer the latest designs. The texture and shades can also change, as these are adapted to the latest fashions. If you can no longer get your desired fabrics or yarns from your supplier, find out about their successors or other products that you could use instead.

## Note on quantities of stabiliser

It is not necessary to cut each pattern piece from a single piece of water-soluble stabiliser; you can join several pieces of stabiliser together to form each part of the pattern. Water-soluble stabiliser is relatively expensive, and the aim is to waste as little of it as possible. As it is eventually washed out, it is perfectly acceptable to put together small pieces of stabiliser, even small shreds, where they will fit. The quantities of stabiliser suggested in the projects take this into account, and should therefore be treated as minimum requirements.

### Silk dyes

These dyes (e.g. Marabu SilkArt) are not only suitable for traditional silk painting and steam fixing, but have also proved to be suitable for use with the microwave technique and the boiling technique for fixing.

### Silk fabrics

Silk fabrics by the metre and ready-made scarves or shawls are indispensable for the Crazy Patchwork technique. Various qualities of fabric are available from specialist suppliers (e.g. Arty's).

### Care instructions for the 'Crazy Patchwork' stabiliser technique

Almost all of the designs shown in this book can be washed in the washing machine, but please make sure that there are no garments with buttons on in the machine at the same time. Buttons and hooks will damage the netting effect, as they can tear seams. Preferably select the 'delicates' wash – up to 40°C (according to colour and fabric – see manufacturer's instructions).

If wool or cashmere is used, then a second wash cycle to remove any spray glue residue should be allowed for.

### Cotton fabrics

Cotton fabrics used for patchwork, with their numerous fine motifs, are just as effective and endlessly compatible with new knitting and special-effect yarns.

### Special-effect yarns

Knitting and crocheting are just as interesting as stitching using special-effect yarns. Crazy Wool offers a completely different way of working with yarn and wool threads. This technique has the added advantage that it only uses 30 per cent of the material needed for knitting.

### Measurements and length

Make sure when selecting your fabric that the width is sufficient; with wool and special-effect yarns you need to know what length it will produce. Your specialist supplier can help you here.

# Dyeing silk

## Microwave technique

### MATERIALS

- silk scarf
- glass dish and cover (microwave accessories)
- silk dye, e.g. Marabu SilkArt
- paintbrush
- microwave (approx. 600 watt)

### INSTRUCTIONS

**1.** Rinse out the silk scarf and place it in the glass dish. Put some dye in the lid of the dye pot and drop it on to the scarf using the pipette.
**2.** Paint the second and third colours as desired on to the remaining white areas of the scarf, using the paintbrush to blend the colours into one another.
**3.** Place the glass dish in the microwave with the cover over the painted scarf and fix in the microwave for approx. 3 minutes.
**4.** Rinse out the scarf with hot water, then rinse with cold water until the water runs clear.
**5.** Iron the scarf dry, cut it into squares, etc. for Crazy Patchwork and follow the rest of the instructions.

## Boil dyeing

### MATERIALS

- 1 saucepan with approx. 5l (176 fl.oz) of fixing medium
- silk dye, e.g. Marabu SilkArt
- 2 tablespoons of salt
- silk fabric

### INSTRUCTIONS

**1.** For approx. 1.5m (59in) of silk, fill the saucepan with 2l (70½ fl.oz) of water and heat to boiling point (the water is lightly bubbling).
**2.** Now pour in 20ml (¾ fl.oz) of silk dye, e.g. Marabu SilkArt, and add the salt. Wet the silk fabric and leave to dye for approx. 5 minutes in the hot dye bath.
**3.** Rinse out the fabric with hot water, then rinse with cold water.
**4.** Iron dry and cut into the desired squares or rectangles for the Crazy Patchwork technique and follow the rest of the instructions.

### TIP

This silk fabric dyeing process can be performed immediately before sewing, as dyeing the fabrics is a very quick process and they dry quickly too.

Do you want a brighter colour? Or should the colour be stronger? You can achieve these effects by dyeing a second time.

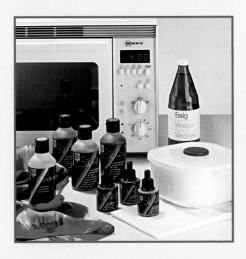

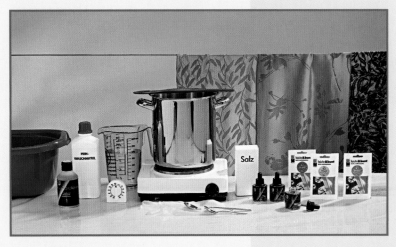

# Foundation course in Crazy Patchwork

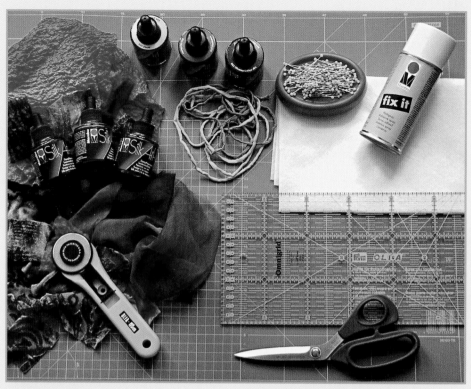

- firm work surface
- water-soluble stabiliser (e.g. Soluvlies by Freudenberg)
- water-soluble spray adhesive
- silk, velvet, embroidered fabrics, lace, etc.
- silk cord
- dressmaking scissors, cutting wheel, ruler
- pins, sewing machine

*TIP*
See 'note on quantities of stabiliser' on page 6.

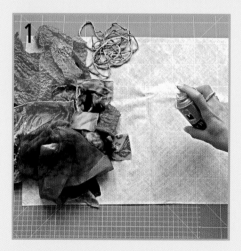

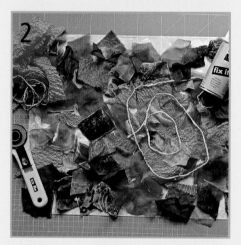

**Preparation of the stabiliser**
Cut out the stabiliser (for the top, bag, etc.) and spray with water-soluble spray adhesive at a distance of 20cm (7¾in) from the surface. Take care to follow the manufacturer's instructions on the spray can. When using wool, spray sparingly.

**Fabrics**
Cut strips 4–5cm (1½–2in) wide from the fabrics, from which you can cut out squares, rectangles or triangles. Lay out as you wish (or according to the photograph of the item) in a 'puzzle' arrangement on the stabiliser. The individual pieces of fabric can overlap one another (one edge can lay on top of another). When the pieces of fabric overlap, a denser effect will be achieved after rinsing out than if the squares were laid next to one another.

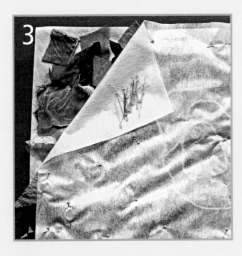

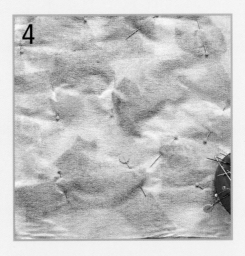

### Neckline and special-effect areas

If the stabiliser has a neckline, lay the pieces of cut fabric around the rounded edge. Lighter areas and interesting effects can be achieved by going, for example, from yellow to red, green and blue into black. Particular effects can be achieved by using several layers of fabric in graded colours.

### Preparing for sewing

Spray the adhesive again over the whole covered area. Ensure that you spray small areas at a time, so that the squares do not fly away. Place a second layer of stabiliser on top and press down lightly with the palm of your hand. Pin the corners and the centre of each outer edge to prevent the inner pieces from slipping.

*TIPS*

You can draw guidelines on the stabiliser using a ballpoint pen and ruler, as the ink will wash out together with the stabiliser when rinsed. Do not use a felt-tip pen though, as the wet colour will transfer to the remaining weave. Felt tip ink cannot be removed afterwards. (See step 4)

Should any of the rows not be as straight as you would like, do not worry about it, as the next row will be better and the one after that will be perfect. Work slowly on your first designer piece. (See step 5)

Only rinse out the stabiliser when no more sewing is required. While the stabiliser is acting as a base, it keeps the seams held together. (See step 6)

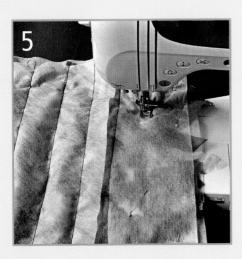

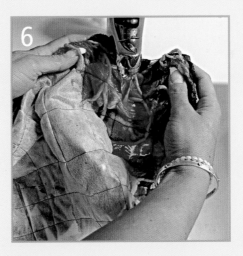

### Sewing

As in the photograph, first sew the lengthways seams vertically, 3–4cm (1¼–1½in) apart, with the sewing machine, using a stitch size of 3–4. When the whole area has been covered with these seams, turn the work and sew the crossways seams in the same way (3–4cm (1¼–1½in) apart) to make a square pattern.

### Rinsing out

Rinse out the work under cold running water. The stabiliser will dissolve in the water without leaving a residue. A little detergent for delicate fabrics will give a soft 'final clean'. Leave to dry and steam if required. Leave the surface of your work un-ironed to emphasise the character of the 'Crazy Patchwork'.

# Foundation course in Crazy Wool

## MATERIALS

- firm cutting base
- water-soluble stabiliser (e.g. Soluvlies by Freudenberg)
- water-soluble spray adhesive
- wool or special-effect yarn
- dressmaking scissors
- cutting wheel
- ruler
- pins
- sewing machine
- sewing weights

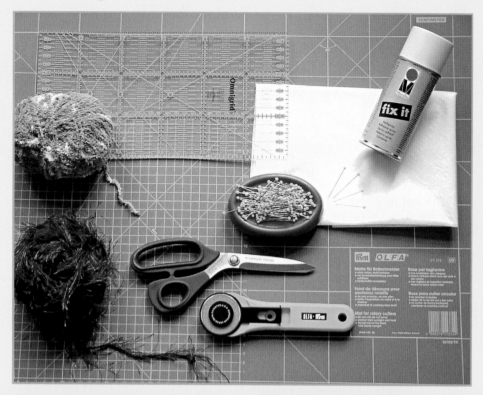

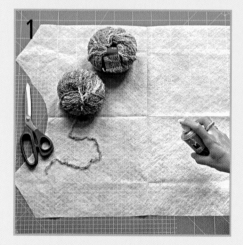

*TIP*
See 'note on quantities of stabiliser' on page 6.

### Preparation of the stabiliser

Cut out the stabiliser according to the templates on pages 42–44 in the measurements given (for the top, bag, etc.) and spray with water-soluble adhesive at a distance of approx. 20cm (7¾in) from the surface. Take care to follow the manufacturer's instructions on the spray can. When using wool, spray sparingly.

### Laying the special-effect yarn

Lay one thread next to another and after covering an area of around 10cm (4in), press down lightly with your palm. Depending on the yarn and wool used, you can allow for a slight tension between the yarn and the stabiliser. Sewing weights will make it easier to work, as they will keep the stabiliser flat on the table.

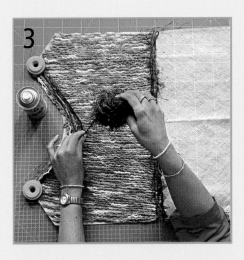

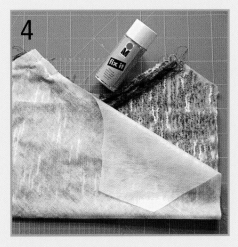

### Neckline and special-effect areas

For tops and sweaters, cut out a small neckline 12cm (4¾in) wide and 3cm (1¼in) deep in the centre of one of the shorter sides. Spray adhesive over the whole stabiliser area. The neckline, edges and detailing can be additionally emphasised using a second colour of yarn/wool. Before placing the second layer of material on top, it is advisable to spray again lightly with adhesive.

### Preparing for sewing

First, re-spray the whole area laid with yarn with adhesive and then cover with the second layer of stabiliser. Press down lightly with the palm of the hand and secure the corners and outer edges with pins to ensure that nothing will slip during sewing.

*TIPS*

You can draw guidelines on the stabiliser using a ballpoint pen and ruler, as the ink will wash out together with the stabiliser. Do not use a felt-tip pen though, as the wet colour will transfer to the remaining weave. Felt-tip ink and anything similar cannot be removed afterwards.
(See step 4)

Only rinse out the stabiliser when no more sewing is required. While the stabiliser is acting as a base, it keeps the seams held together.
(See step 5)

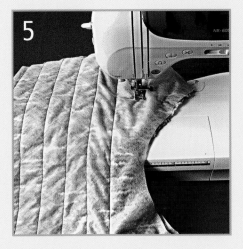

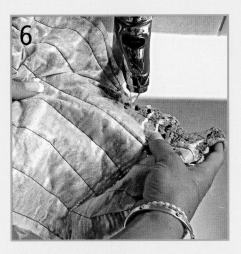

### Sewing

As in the photograph, first sew seams at right angles to the lengthways wool threads 3–4cm (1¼–1½in) apart. This fixes the strips of yarn to the stabiliser, holding them together. Machine-stitch around the neckline in a slight curve. Sewing-machine stitch size 3–4 is the best and ensures the necessary elasticity after rinsing out the stabiliser. If desired, the side seams can also be sewn with a narrow zigzag stitch.

### Rinsing out the stabiliser

The stabiliser will rinse out without residue under cold running water. It is advisable to use a little detergent for delicate fabrics when rinsing out the stabiliser, so that the garment will feel soft when dry and free of stabiliser. Leave the garment to dry and iron flat if needed. Wool and special-effect yarns will keep their shape better if steaming and ironing are avoided.

*This easy, attractive top can be adapted to fit all sizes.*

## 'Crazy wool' top
**Size:**
10–12

**Level of difficulty:**

## Scarf
**Size:**
180 × 30cm (70¾ × 11¾in)

**Level of difficulty:**

# Easy and effective

**This garment is an easy introduction to the 'crazy' technique. Needing just 100g (3½oz) of special-effect yarn and only around two hours of your time to make, you can quickly produce a smart top for any occasion.**

## 'Crazy wool' top

### MATERIALS

- water-soluble stabiliser, e.g. Soluvlies by Freudenberg, 140 × 90cm (55 × 35½in)
- water-soluble spray adhesive
- multicoloured special-effect textured yarn (50% combed cotton/50% viscose): 50g (1¾oz) in both oranges and yellows
- special-effect ribbon yarn in orange/yellow, approx. 10g (¼oz)
- sewing thread in orange

### INSTRUCTIONS

**1.** Cut out the stabiliser 55 × 55cm (21¾ × 21¾in) for the front and back pieces according to the template on page 42. Cut a small neckline at the centre of the top edge of the front piece 12cm (4¾in) wide and 3–4cm (1¼–1½in) deep.
**2.** Spray the whole stabiliser surface with spray adhesive. Cover completely with vertical threads (see the basic technique on pages 10–11) in orange-coloured yarn with the threads approx. 3cm (1¼in) apart and press down lightly. Then place yellow threads in the spaces between the orange threads and press down.
**3.** Proceed in the same way for the back piece. Place the front and back right sides together and stitch the shoulder and side seams with the sewing machine. Turn right side out and rinse.
**4.** When the garment is dry, finishing touches can be made, e.g. deepening the neckline. The seams that have been cut can be secured with a few hand-stitches and finished off.

## Scarf

### MATERIALS

- water-soluble stabiliser, e.g. Soluvlies by Freudenberg, 180 × 90cm (70¾ × 35½in)
- water-soluble spray adhesive
- multicoloured special-effect textured yarn (50% combed cotton/50% viscose): approx. 10g (¼oz) in both oranges and yellows
- special-effect ribbon yarn in orange/yellow, approx. 8g (¼oz)
- sewing thread in orange

### INSTRUCTIONS

**1.** Cut the stabiliser into four 90 × 45cm (30½ × 17¾in) rectangles and place together in pairs.
**2.** Spray the first stabiliser surface with spray adhesive and place the special-effect yarns randomly in succession, as in the photograph. Keep spraying with adhesive as you go along to secure the threads to the stabiliser.
**3.** Spray again with adhesive and then lay on the second layer of stabiliser. Push any threads hanging over the edge of the stabiliser in between the stabiliser layers before stitching. Machine-stitch in squares or in wavy lines (see page 9). The distance between the seams should be no more than 3–4cm (1¼–1½in).

### TIP

*To enlarge to size 14/16 (L) or 18/20 (XL) add 5cm (2in) each to the basic template in width and length:*
*Size 14/16 = stabiliser 60 × 60cm (23½ × 23½in)*
*Size 18/20 = stabiliser 65 × 65cm (25½ × 25½in)*

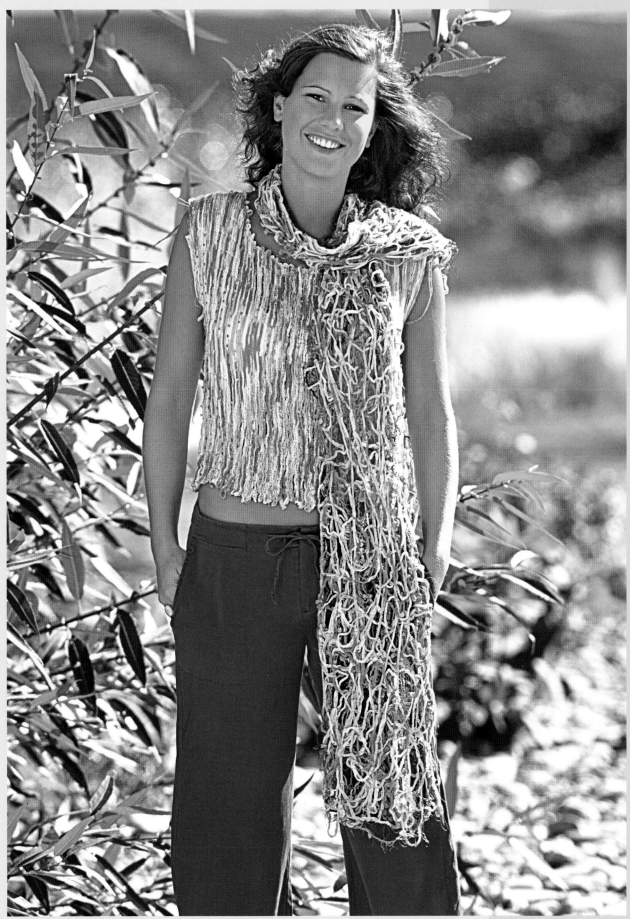

*Despite its spring colours, this sweater can be worn at any time.*

## Sweater in pastel

**Size:**

12–14

**Level of difficulty:**

◆

# Chic in silk

**This garment is in classic spring colours with narrow sleeves. The materials and colours are in complete harmony. Leftover pieces of silk in white could also be incorporated into the design.**

## Sweater in pastel

### MATERIALS

- water-soluble stabiliser, e.g. Soluvlies by Freudenberg, 180 × 90cm (70¾ × 35½in)
- pongé 06, 90 × 20cm (37½ × 7¾in)
- chiffon, 90 × 20cm (37½ × 7¾in)
- 1 velvet scarf 110 × 30cm (43¼ × 11¾in)
- 1 devoré scarf 110 × 20cm (43¼ × 7¾in) (e.g. Artys)
- 4–5 silk cords
- silk dye, e.g. Marabu SilkArt, in magenta, mid-yellow, dark ultramarine, orange, Bordeaux, sapphire and May green
- water-soluble spray adhesive
- sewing thread in either light blue or pastel

### INSTRUCTIONS

**1.** Cut the stabiliser into four squares of 50 × 50cm (19¾ × 19¾in) and prepare according to the basic technique on pages 8–9.
**2.** Dye the fabric following the dyeing instructions on page 7. Dye all the pieces of fabric to the desired pastel shade, e.g. fold the devoré scarf in half and colour one half pink (magenta) and yellow and the other half May green and blue. Then cut all the pieces of fabric into squares of 4 × 4cm (1½ × 1½in).
**3.** Spray two pieces of stabiliser with adhesive and cover with the fabric squares as in the photograph. Spray again with adhesive and cover each of the pieces with the second piece of stabiliser.
**4.** First stitch the lengthways seams and then the crossways seams. Set the sewing machine to stitch size 3. The distance between the seams should be no less than 3cm (1¼in).

**5.** For the sleeves, cut the stabiliser according to the template on page 42 and proceed as for the sweater pieces.
**6.** Place the front and back pieces right sides together, stitch the shoulder seams and pin together the sleeves. Pin the centre of the sleeve to the shoulder seam and then continue pinning round to the right and to the left.
**7.** Sew up the seam around the armhole using the sewing machine. Close up the sleeve from the bottom edge (wrist) to under the arm and continue sewing down the side seams of the front and back pieces. Rinse out the piece. Attach the second sleeve in the same way.

### *TIPS*

*To dye in the microwave: the dyes are mixed with water in a ratio of 2:1, i.e. 10ml (¼fl.oz) dye plus 5ml (⅛fl.oz) water. This will produce pastel shades (see photograph).*
*To dye by boiling: leave the fabrics for just 3–4 mins in the hot liquid dye.*

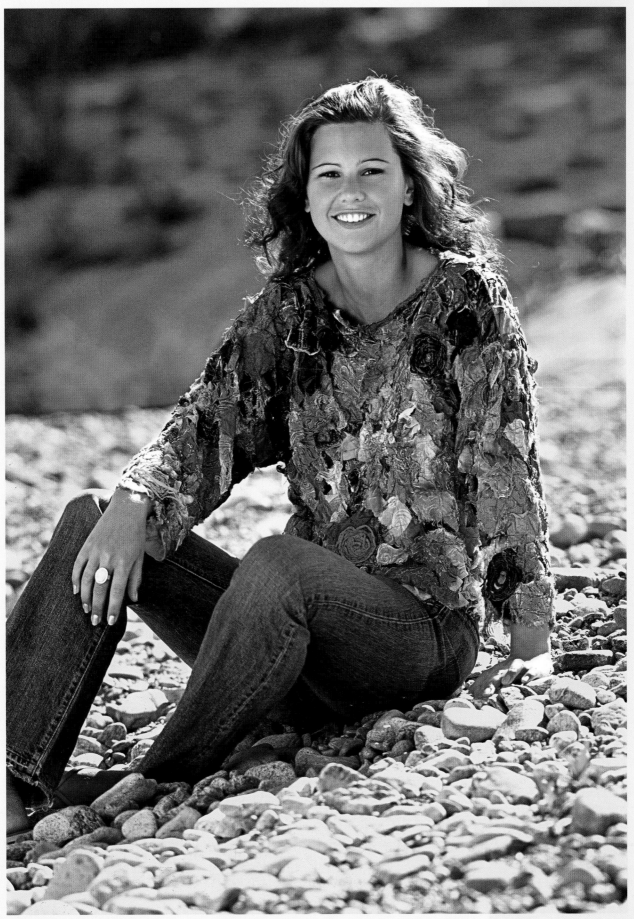

# Silk meets towelling

**Strong colours combined with light silk make this bag an absolute must-have for the summer. The fabric mix of silk and towelling is unusual and makes this casual bag very durable.**

*This bag is not only a gloriously colourful accessory, but also has plenty of room for all your essentials.*

## Casual bag

**Size:**
60 × 40cm (23½ × 15¾in)

**Level of difficulty:**

## Casual bag

### MATERIALS

- water-soluble stabiliser, e.g. Soluvlies by Freudenberg, 150 × 90cm (59 × 35½in)
- water-soluble spray adhesive
- silk fabrics (any quality), approx. 120 × 40cm (47¼ × 15¾in)
- silk dye, e.g. Marabu SilkArt, in magenta, mid-yellow, dark ultramarine, orange, Bordeaux, sapphire and May green
- 2 striped, towelling tea-towels
- cotton interfacing, natural shades, 120 × 80cm (47¼ × 31½in)
- sewing thread in blue or black
- patchwork fabric, flame yellow, 115 × 80cm (45¼ × 31½in)

### INSTRUCTIONS

**1.** Cut the stabiliser according to the template on page 43 into two rectangles, each 80 × 60cm (31½ × 23½in), and spray with spray adhesive.

**2.** Dye all the pieces of silk according to the instructions on page 7. Cut the silk and the towelling tea-towels into squares each 5 × 5cm (2 × 2in). Cover the stabiliser with a colourful mix of these pieces of fabric and proceed following the basic 'Crazy Patchwork' technique on pages 8–9.

**3.** Cut out a rectangle 80 × 60cm (31½ × 23½in) from the cotton interfacing and on the reverse side of the 'Crazy' design sew down around all four sides.

**4.** For the bag lining, cut a rectangle 80 × 60cm (31½ × 23½in) from the yellow patchwork fabric. Fold the piece of fabric in half lengthways and stitch the side edges.

**5.** For the shoulder straps, cut two strips 130 × 10cm (51¼ × 4in) from both the yellow patchwork fabric and the towelling fabric. Place one cotton strip and one towelling strip right sides together and stitch the side seams. Proceed in the same way for the other shoulder strap.

**6.** Turn the shoulder straps right side out and pin to the outside of the bag opening as indicated in the diagram on page 43.

**7.** Pull the lining over the outside of the bag, right sides together, and sew both pieces together along the top edge. Turn the whole bag inside out through the opening at the bottom of the bag lining and then sew up the opening.

### TIP

*If you have made the sweater on page 14 and have some leftover pieces of dyed silk fabric, you can use these pieces for the bag. Sew inside pockets using strips of fabric 30 × 40cm (11¾ × 15¾in), so that you can organise the contents of your bag (keys, purse, etc.) more easily and find things quicker.*

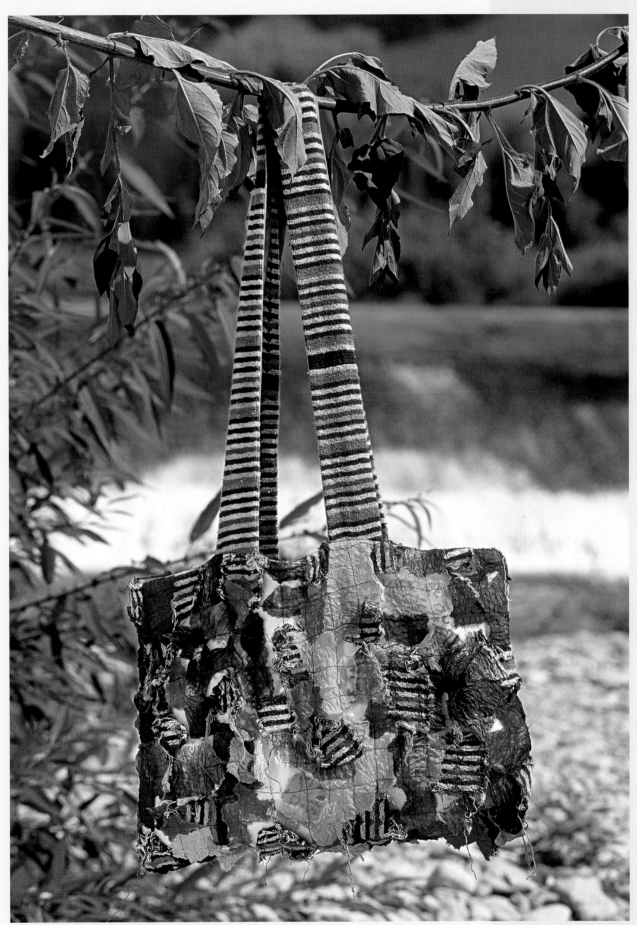

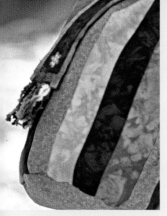

*Children and young people will particularly like this outfit.*

## Sweater with ¾ sleeves
**Size:**
10–12
**Level of difficulty:**
◆◆◆

## Bag
**Size:**
60 × 40cm (23½ × 15¾in)
**Level of difficulty:**
◆◆◆

# Matching green and blue

**Shades of turquoise will always add a breath of fresh air to your wardrobe. This bright microfibre yarn is cosy to wear and works really well with olive and blue tones. The bag adds an extra touch to the outfit. Stripes are always fashionable.**

## Sweater with ¾ sleeves
### MATERIALS

- water-soluble stabiliser, e.g. Soluvlies by Freudenberg, 160 × 90cm (63 × 35½in)
- soft, printed yarn (100% polyamide) in turquoise and green, 150g (5¼oz)
- water-soluble spray adhesive
- eyelash yarn in dark blue, approx. 15g (½oz)
- sewing thread

### INSTRUCTIONS

**1.** Prepare the stabiliser according to the basic 'Crazy Wool' technique on pages 10–11 and make the neckline.
**2.** Lay the Leggero Print yarn, placing the threads vertically next to each other (see the basic 'Crazy Wool' technique on pages 10–11) and press down. Spray with adhesive.
**3.** In the centre of the front piece, place the dark blue yarn in a jagged pattern on to an area of approx. 15 × 10cm (6 × 4in). Further effects can be achieved with the darker yarn around the neckline (see photograph).
**4.** Spray on a second layer of adhesive. Place the second layer of stabiliser on top and press down. Pin the corners of the piece to prevent it from slipping when sewing.
**5.** Proceed in the same way for the back piece and the sleeves (see the basic sweater template on page 42). Place the front and back pieces right sides together and stitch the shoulder seams.
**6.** Mark the centre on the first sleeve on the top side and pin to one of the shoulder seams at the centre. Then pin the sleeve to the front and back pieces.
**7.** Stitch the seam around the armhole. Then close up the sleeve from the bottom edge (wrist) to under the shoulder and continue sewing down the side seams of the front and back pieces. Attach the second sleeve in the same way. Rinse out the piece.

## Bag
### MATERIALS

- patchwork fabric in plain and patterned apple green, turquoise and royal blue, each 80 × 40cm (31½ × 15¾in)
- plain fabric with textured pattern in apple green, turquoise and royal blue, each 80 × 60cm (31½ × 23½in)
- iron-on interfacing, e.g. Vlieseline H200 by Freudenberg, 90 × 60cm (35½ × 23½in)
- cotton fabric in plain apple green, 80 × 60cm (31½ × 23½in)
- sewing thread

### INSTRUCTIONS

**1.** Cut strips 40 × 5cm (15¾ × 2in) (including 0.5cm (¼in) seam allowance): five in plain apple green, four in patterned apple green, five in patterned turquoise and six in royal blue.
**2.** Cut out two rectangles 18 × 16cm (7 × 6¼in) for the base, iron on to the interfacing and cut into an oval shape.
**3.** For the outside of the bag, stitch strips to one another to make a surface of 60 × 40cm (23½ × 15¾in). Iron the seams on the reverse side and stitch the side seam.
**4.** Place the base and the lower edge of the outside of the bag right sides together, pin and sew.
**5.** For the bag lining, cut out the plain apple green fabric 60 × 40cm (23½ × 15¾in) and sew the side seam. Pin the base to the lower outside edge of the lining bag and sew, leaving an opening for turning of approx. 15cm (6in).
**6.** Cut two strips 100 × 4cm (39¼ × 1½in) (including 0.5cm (¼in) seam allowance) each from the blue and plain apple green fabric for the shoulder straps. Place each green and blue strip right sides together, sew both of the long sides and turn right side out.
**7.** For the flap, cut strips approx. 27 × 6cm (10¾ × 2¼in) from the leftover fabric after cutting out the exterior of the bag. Fold in half lengthways, right sides together, sew and turn right side out. Attach right sides together at the centre of the bag opening and stitch down.
**8.** Pin the shoulder straps on either side approx. 5cm (2in) from the sides of the bag. Pull the bag lining over the outside of the bag, right sides together, then sew both bag pieces together at the opening. Turn the bag lining right side out through the opening at the base and sew up the opening.

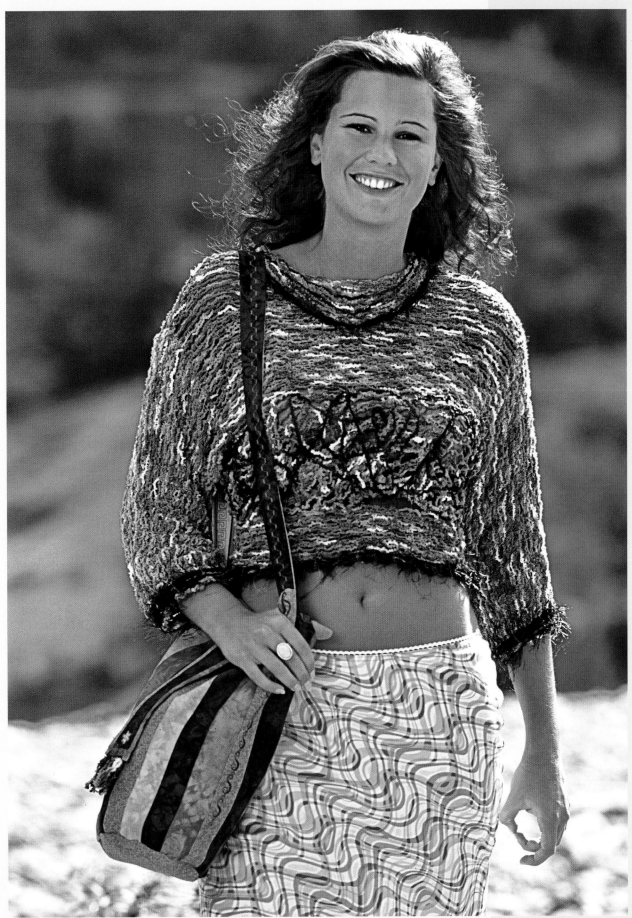

*This scarf is chic and simple to make.*

## Scarf

**Size:**
84 × 84cm (33 × 33in)

**Level of difficulty:**

◆

# Set off by a scarf

**This scarf, which has so far perhaps been missing from your patterned collection, will go just as well with the matching accessories as it will with difficult colour combinations. It matches just about anything. Try it out and see – you will love it.**

## Scarf

### MATERIALS

- water-soluble stabiliser, e.g. Soluvlies by Freudenberg, 180 × 90cm (70¾ × 35½in)
- water-soluble spray adhesive
- pongé 06, 90 × 20cm (35½ × 7¾in)
- crinkle silk, 90 × 20cm (35½ × 7¾in)
- 1 velvet scarf 110 × 30cm (43¼ × 11¾in)
- 1 devoré scarf 110 × 20cm (43¼ × 7¾in) (e.g. Artys)
- silk dye, e.g. Marabu SilkArt, in magenta, mid-yellow, cyan, dark ultramarine, orange, Bordeaux, sapphire, leaf green and black
- multicoloured aran (worsted) yarn (60% cotton/40% acrylic) in turquoise, blue and white, 15g (½oz)
- sewing thread in either black or dark blue

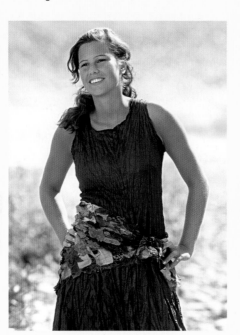

### INSTRUCTIONS

**1.** Cut two pieces of stabiliser 84 × 84cm (33 × 33in). Place one piece on the work surface and spray with adhesive.
**2.** Dye the silk fabrics according to the dyeing instructions on page 7, then cut into squares 5 × 5cm (2 × 2in) and 4 × 4cm (1½ × 1½in).
**3.** Lay the squares on the stabiliser in the following way from the centre outwards: first arrange yellow squares on a surface of approx. 10 × 10cm (4 × 4in), continue with orange squares, then red and then lilac pieces; then fill the rest of the area with green, followed by dark blue and finally black. Use up all the squares so that they border one another. If the scarf needs to be opaque, they can overlap each other by approx. 0.5cm (¼in).
**4.** Once the whole area is covered, spray again with spray adhesive. Arrange the yarn in a spider's web on to the fabric surface.
**5.** Cover the covered areas with a second layer of stabiliser and press down lightly. Secure the corners with pins and first stitch lengthways seams 4cm (1½in) apart, then the crossways seams in a square quilting pattern, as described on page 9. Rinse out the fabric.

### TIP

*This scarf is not just perfect for the cold season. Silk is comfortable to wear and in summer this item can be used as a hip scarf with its light and airy feel.*

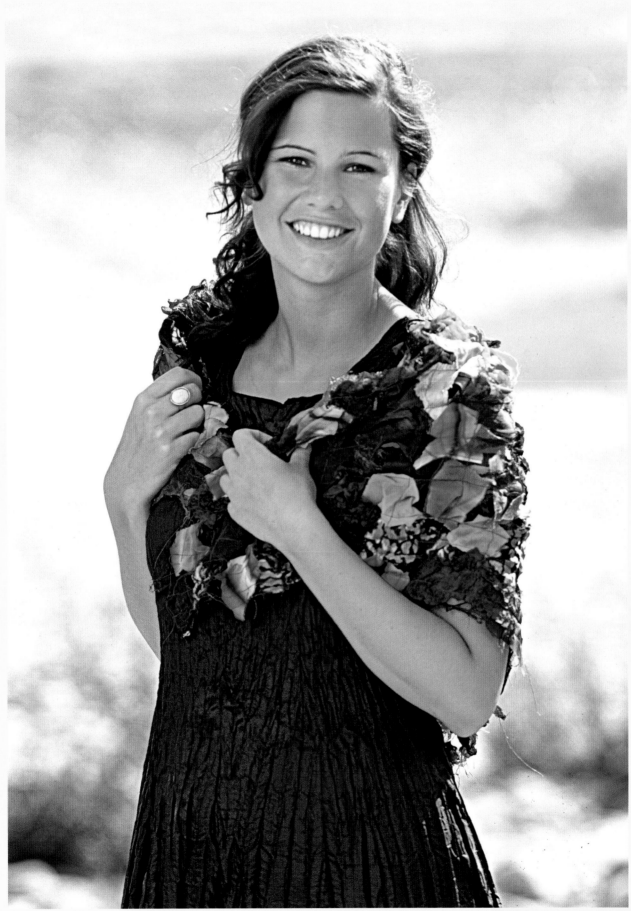

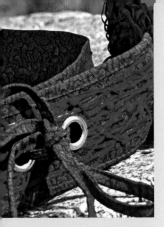

*An unusual material mix, which you won't see every day*

## Bag
**Size:**
40 × 40cm (15¾ × 15¾in)

**Level of difficulty:**

## Belt
**Size:**
Length 100cm (39¼in)

**Level of difficulty:**

# Red for power-dressing

These accessories are not just for fans of black and red, they will also liven up orange, yellow and olive. The belt has room for adjustment if you lose or gain weight. The bag is great for shopping, as well as going out. A completely new combination of fabric and raffia.

## Bag
### MATERIALS

- cotton fabric with a small pattern in orange/red (for the exterior of the bag), 80 × 40cm (31½ × 15¾in)
- cotton fabric in plain orange/red (for the bag lining), 80 × 40cm (31½ × 15¾in)
- water-soluble stabiliser, e.g Soluvlies by Freudenberg, 90 × 60cm (35½ × 23½in)
- stiff pelmet interfacing (available from Vlieseline), 110 × 40cm (43¼ × 15¾in)
- water soluble spray adhesive
- natural raffia in red, 50g (1¾oz)
- pompom yarn (100% nylon) in red, 15g (½oz)
- sewing thread

### INSTRUCTIONS

**1.** Cut out the cotton fabric according to the template on page 44 (see above for measurements).
**2.** For the straps, cut two pieces each from the patterned fabric and the stabiliser 100 × 6cm (39¼ × 2¼in). Cut a base for both the exterior and the lining of the bag, as well as two bases from the pelmet interfacing (see diagram on page 44). Iron each fabric base on to a piece of pelmet interfacing.
**3.** Spray the patterned fabric with adhesive, randomly place the raffia on top, press down lightly and spray again with adhesive.
**4.** Place the pompom yarn in the spaces in between (see photograph). Place small rosettes approx. 4cm (1½in) in diameter, using two strands of raffia for each, on to a piece of stabiliser the size of the shoulder strap, spray with adhesive and cover with stabiliser. Arrange these rosettes on the bag (see photograph) and cover the whole area with stabiliser. Sew on according to the basic 'Crazy Patchwork' technique on pages 8–9.
**5.** Cut out the lining according to the measurements; fold in half lengthways. Stitch the side seam, leaving 15cm (6in) open for turning. Lay the base pieces right sides together, pin and sew.
**6.** Iron the interfacing with the adhesive side facing the shoulder straps. Turn the fabric edges in 1.5cm (½in) level with the interfacing, iron down and sew.
**7.** Push the exterior of the bag into the lining, right sides together, and stitch along the side seam. Pin the base piece, right sides together, to the lower edge of the bag, stitch and turn right side out.

**8.** Pin each strap 5cm (2in) from the side edges, between the exterior and the lining of the bag, and stitch to the upper edge. Turn the bag through the opening (lining) and sew up the opening. Rinse out.

## Belt

### MATERIALS

- stiff pelmet interfacing (available from Vlieseline), 90 × 7cm (35½ 2¾in)
- cotton fabric with a small pattern in orange/red 100 × 10cm (39¼ × 4in)
- cotton fabric with a small pattern in orange/red (for the tie cords), 100 × 5cm (39¼ × 2in)
- sewing thread
- water-soluble spray adhesive
- natural raffia in red, 10g (¼oz)
- pompom yarn (100% nylon) in red, 4–5 threads, each 1m (39¼in) long
- water-soluble stabiliser, e.g. Soluvlies by Freudenberg, 90cm (35½in) wide, 7–8cm (2¾ × 3¼in)
- 2 metal rings, diameter 20mm (¾in) (e.g. Prym)

### INSTRUCTIONS

**1.** Iron the interfacing on to the wider strips. Turn over. Place the second strip on top right sides together, stitch along the short ends and along one long side. Stitch just halfway along the second long side. Turn the belt right side out through the opening and close the opening. Iron over lightly and spray with spray adhesive.
**2.** Place the leftover pieces of raffia and yarn on to the belt, spray with adhesive and cover with a strip of stabiliser. Stitch on the raffia and yarn with two lengthways seams 2cm (¾in) apart. Sew wavy lines over the belt. Rinse out.
**3.** Turn in the edges of the strips by 1cm (½in) for the cords and iron, fold in half and iron, then stitch. To ensure that the belt fits perfectly, take measurements from your own body (slung half over waist and half over hips).
**4.** Place a ring approx. 10cm (4in) away from the end. Place the second ring approx. 3–4cm (1¼ × 1½in) further in. Insert according to the manufacturer's instructions. Sew the cords in the centre of the other end of the belt. Pull the ends of the cords through each ring and tie in a bow.

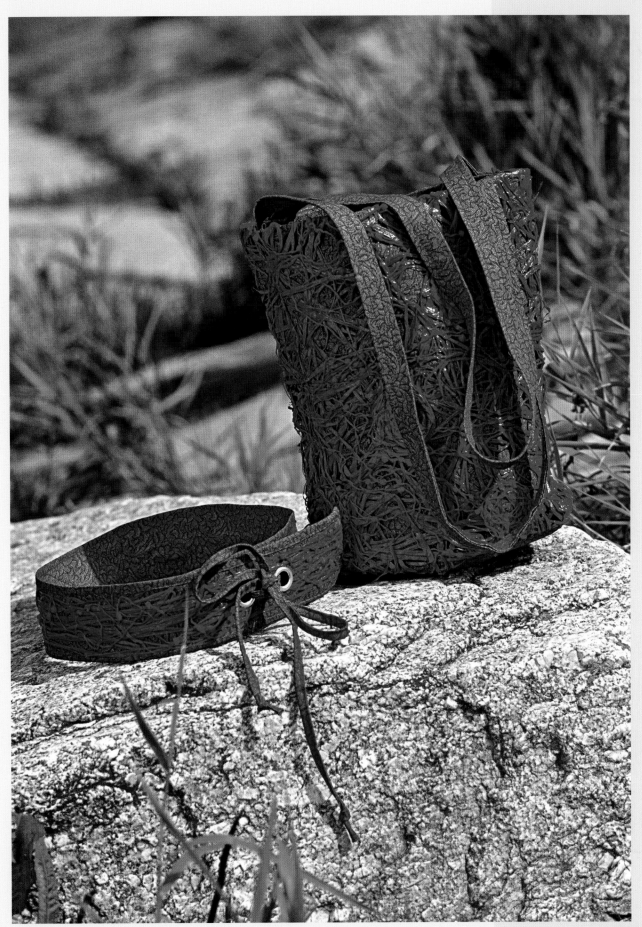

*A dreamy mix of silks that you'll love to wear!*

## 'Fantasy' silk sweater

**Size:**

12–14

**Level of difficulty:**

# Pretty and colourful

**As colourful as a glowing summer meadow – the strong colours and light silks make this sweater a must-have for the summer, going well with skirts and trousers in many colours.**

## 'Fantasy' silk sweater

### MATERIALS

- water-soluble stabiliser, e.g. Soluvlies by Freudenberg, 180 × 90cm (70¾ × 35½in)
- pongé 09, 90 × 90cm (35½ × 35½in)
- 2 velvet scarves in rose or floral design 110 × 30cm (43¼ × 11¾in)
- crinkle crêpe silk, 90 × 40cm (35½ × 15¾in)
- silk dye, e.g. Marabu SilkArt, in lemon, magenta, mid-yellow, cyan, dark ultramarine, orange, Bordeaux, sapphire and black
- water-soluble spray adhesive
- 4–5 silk cords

### INSTRUCTIONS

**1.** Prepare the stabiliser according to the basic technique on pages 8–9 and make the neckline.

**2.** Dye the fabrics according to the dyeing instructions on page 7. Dye all the pieces of fabric in pastel shades to the desired tone. Cut into squares 5 × 5cm (2 × 2in) and place these on the stabiliser (sprayed with adhesive) working from the centre outwards (see basic technique on pages 8–9). Start on the front piece using yellow (a highlight in the centre), continue with orange squares, then red and finally lilac pieces. Then fill the rest of the area with green, followed by dark blue and finally black. Press the pieces of fabric down lightly and spray with spray adhesive.

**3.** From the leftover stabiliser after cutting out the sweater, cut squares approx. 10 × 10cm (4 × 4in). Place the silk cords on these pieces of stabiliser in spirals and fix with spray adhesive and then arrange on the sweater.

**4.** Lay the second layer of stabiliser on top and press down. Fix the corners with pins to secure the piece and prevent it from slipping when sewing.

**5.** Proceed in the same way for the back and sleeves (see templates on page 42). Place the front and back right sides together and stitch the shoulder seams using the sewing machine.

**6.** Mark the centre of the sleeve on the upper edge and pin the sleeve to the centre of one of the shoulder seams. Pin it first to the front piece and then to the back piece. Stitch the seam with the sewing machine and then continue under the sleeve and down to close the side seam between the front and back pieces. Rinse out.

**7.** When the garment is dry, alterations can be made, for example enlarging the neckline. The seams that have been cut can be secured with a few stitches by hand and then finished off.

### TIP

*If you do not want to buy new pongé silk especially for this garment, you can always use a scarf from your collection of materials that has already been dyed.*

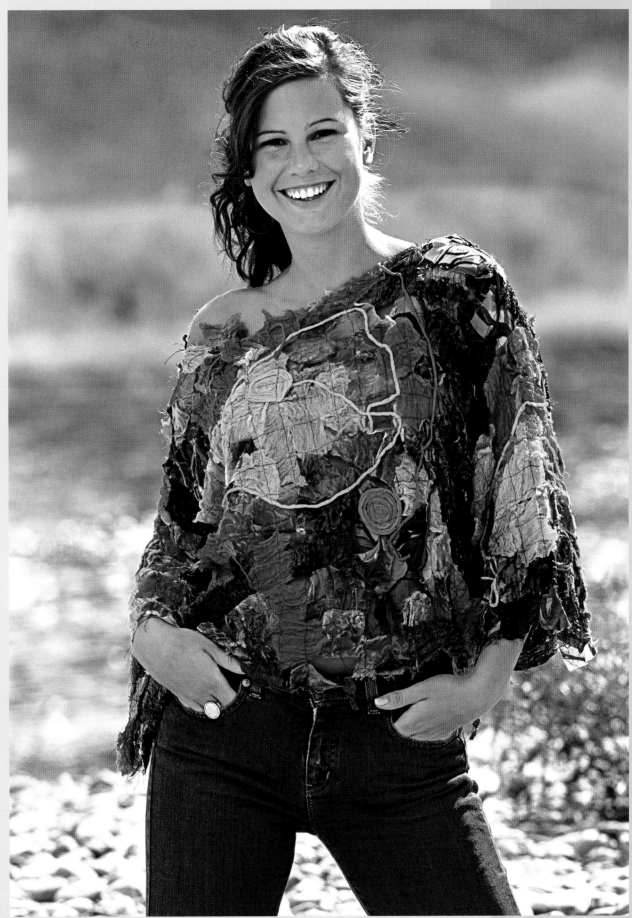

*A sparkly effect for dull days – a sweater to cheer you up!*

## Sweater
**Size:**
12–14

**Level of difficulty:**

## Bag
**Size:**
Approx. 80 × 60cm
(31½ × 23½in)

**Level of difficulty:**

# Great for travelling

**This sweater will bring a bit of a sparkle to your day with its fashionable ribbon yarn. Even a slightly older skirt or pair of trousers will turn into a smart outfit when combined with this top. By adding the bag, you can quickly add a bit of pizazz to denim too when travelling.**

## Sweater

### MATERIALS

- water-soluble stabiliser, e.g. Soluvlies by Freudenberg, 140 × 90cm (55 × 35½in)
- water-soluble spray adhesive
- nylon multicoloured ribbon yarn, 100g (3½oz)
- sewing thread in orange or metallic multicoloured sewing thread

### INSTRUCTIONS

**1.** Cut the stabiliser for the front and back pieces 55 × 60cm (21¾ × 23½in) according to the template on page 42.
**2.** Cut out the stabiliser for the sleeves four times: lower edge 25cm (9¾in), upper edge 45cm (17¾in), arm length 30cm (11¾in) (for short sleeves).
**3.** Starting with the front piece, place a piece of stabiliser on the work surface and spray with adhesive. Lay the pieces of yarn (according to the basic technique on pages 10–11) vertically on to the stabiliser (see the photograph).
**4.** For the neckline, push down the threads on the front piece in the centre approx. 3cm (1¼in) and spray this part again with adhesive. Place three to four threads around the neckline. Press down lightly and place the second layer of stabiliser on top.
**5.** Proceed in the same way for the back piece (without the neckline) and both sleeves. Machine-stitch crossways from side seam to side seam, as the threads laid run lengthways. Leave approx. 3cm (1¼in) between the machine-stitching.
**6.** Close the shoulder seams, then pin the sleeve at the centre to the shoulder seam at the top. First pin on to the front piece and then on to the back piece. Sew the seam with the sewing machine and then close up the underside of the sleeve and the side seam between the front and back pieces. Rinse out.
**7.** Proceed in the same way for the other sleeve. Turn the piece right side out and rinse out.

## Bag

### MATERIALS

- water-soluble stabiliser, e.g. Soluvlies by Freudenberg, 120 × 90cm (47¼ × 35½in)
- nylon multicoloured ribbon yarn, 100g (3½oz)
- 1 roll of sewing thread in orange or metallic multicoloured sewing thread, approx. 200m
- cotton fabric in light green, approx. 115 × 60cm (45¼ × 23½in)

### INSTRUCTIONS

**1.** Cut the pieces of stabiliser according to the template on page 43 and proceed as for the sweater on the left.
**2.** Cut out two strips 80 × 4cm (31½ × 1½in) from the stabiliser for the shoulder straps and then cover lengthways with the ribbon yarn. Machine-stitch crossways with seams approx. 2–3cm (¾–1¼in) apart.
**3.** For the lining, cut out a piece of cotton fabric 80 × 60cm (31½ × 23½in) and sew the side seam, leaving a 15cm (6in) opening for turning.
**4.** Pin the shoulder strap to the exterior of the bag and push the bag into the lining, right sides together. Stitch the upper edge of the bag and turn right side out through the opening, then sew up the opening. Rinse out.

### TIP

*After rinsing out, iron the bag once it is dry. Set the iron to 'silk' so that you can iron over all of the ribbon yarn.*

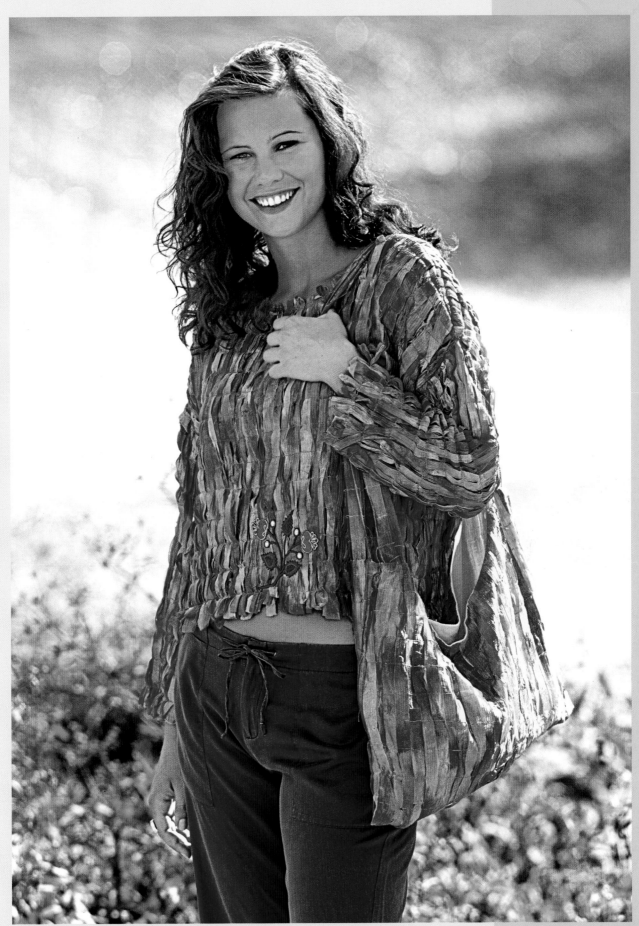

*Women of all ages will love the high-fashion look of this sweater*

## Short-sleeved sweater
**Size:**
12–14
**Level of difficulty:**

## Ribbon neckerchief
**Size:**
55 × 55cm (21¾ × 21¾in)
**Level of difficulty:**

# Look dazzling

**You will love the short-sleeved version of this ribbon sweater too. The shorter sleeves and larger neckline make this top lighter and more pleasant for warmer weather. The slight gleam gives this sweater the luxurious feel of a designer piece.**

## Short-sleeved sweater

### MATERIALS

- water-soluble stabiliser, e.g. Soluvlies by Freudenberg, 140 × 90cm (55 × 35½in)
- nylon multicoloured ribbon yarn, 120g (4¼oz)
- water-soluble spray adhesive
- sewing thread in orange or metallic

### INSTRUCTIONS

**1.** Cut the stabiliser for the front and back pieces and the sleeves according to the template on page 42 and prepare according to the basic 'Crazy Wool' technique on pages 10–11. Shorten the sleeves for this version by 20cm (7¾in) from the lower edge.
**2.** Place the pieces of ribbon yarn vertically next to one another on the stabiliser. To make the sweater opaque, they should overlap by approx. 0.3cm (¼in). Spray again with adhesive.
**3.** After covering the front and back pieces, make the neckline into a round shape in the centre using your hands (depth of neckline approx. 5cm (2in)) or cut out as a final step after rinsing out the sweater. (For neckline length and depth see cutting template on page 42.)
**4.** Finish preparing the sweater according to the 'Crazy Wool' technique on pages 10–11, stitch together and rinse out.

### TIP

*Before laying the ribbon yarn, it can be ironed on to the stabiliser. Set the iron to 'silk'.*

## Ribbon neckerchief

### MATERIALS

- neckerchief
- silk dye, e.g. Marabu SilkArt, in magenta (pink), yellow and orange
- 8 skeins of ribbon, each approx. 65–70cm (25½–27½) long
- sewing thread in orange or metallic

### INSTRUCTIONS

**1.** Colour and fix the neckerchief with silk dyes in the following order: pink, yellow and orange, using the microwave technique on page 7. Rinse out and iron dry.
**2.** Place ribbons side by side directly up to the edge of the neckerchief and stitch on.

### TIP

*By attaching the ribbons with pins to the scarf before sewing, it will be easier to sew them on in a straight line. Water-soluble spray adhesive can be used instead of pins, but it should be used sparingly. The scarf must then be rinsed out again once it has been made to remove the spray adhesive.*

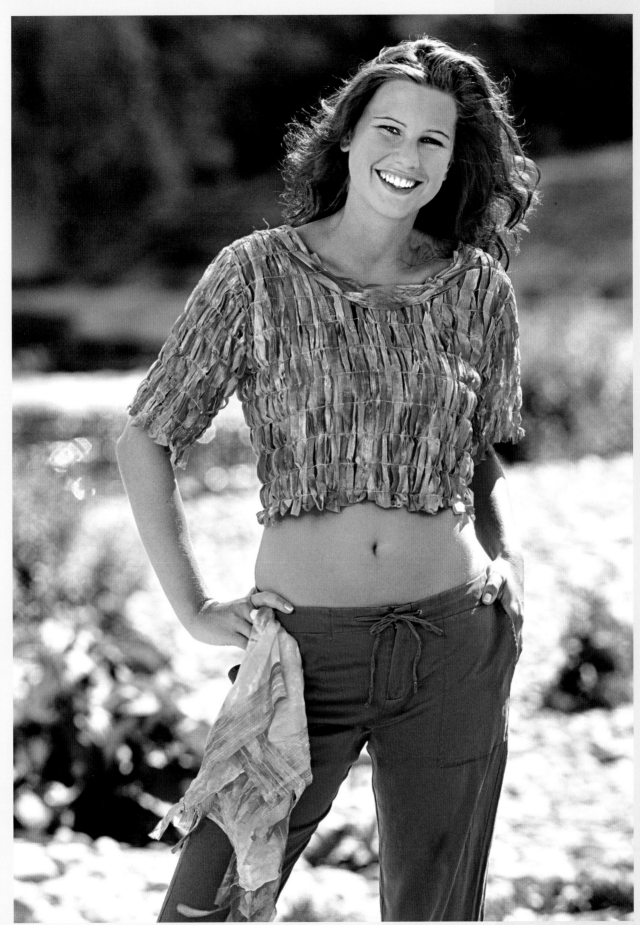

*This novel denim skirt will go with any top.*

**Skirt**
**Size:**
According to the size of the jeans
**Level of difficulty:**

# New from old

**Make a high-fashion, denim skirt from an old pair of jeans. By mixing cut pieces of denim with coloured silk, you will love this skirt with its new twist on the traditional 'jeans look'.**

## Skirt

### MATERIALS

- 1 pair of old jeans
- pongé 06, 90 × 20cm (35½ × 7¾in)
- crêpe de Chîne 08, 90 × 20cm (35½ × 7¾in)
- chiffon, 90 × 40cm (35½ × 15¾in)
- silk dye, e.g. Marabu SilkArt, in magenta, violet, dark ultramarine, cherry red and black
- water-soluble stabiliser, e.g. Soluvlies by Freudenberg, 260 × 90cm (102¼ × 35½in)
- water-soluble spray adhesive
- sewing thread in dark blue

### INSTRUCTIONS

**1.** Cut off the jeans at the bottom of the zip, so that the crotch is open. Cut the leg pieces into squares approx. 5 × 5cm (2 × 2in).
**2.** Dye the silk fabrics according to the photograph and the dyeing instructions on page 7. Cut these too into squares 5 × 5cm (2 × 2in) or into triangles of any size.
**3.** Cut out the stabiliser according to the desired skirt length and width: the skirt panels should measure 30cm (11¾in) at the top (around the waistband), 45cm (17¾in) at the bottom (around the hemline) and be 115cm (45¼in) long.
**4.** Cover the stabiliser pieces with the silk pieces and prepare according to the 'Crazy Patchwork' technique on pages 8–9.
**5.** Once the machine-stitching is done, place the skirt panels right sides together and stitch the side seams with the sewing machine.
**6.** Place the skirt piece right sides together with the jeans piece, so that the top edge of the skirt piece is laying exactly over the bottom edge of the cut-off jeans. Slightly gather the edge of the skirt and stitch. Turn right side out and wash.

### TIP

*If you discover after washing that the skirt is too long, cut off the excess fabric with dressmaking scissors. That way there will be no additional sewing.*
*If you still want to use the trouser-leg pieces from the knee to the hem, you can make a top from them.*

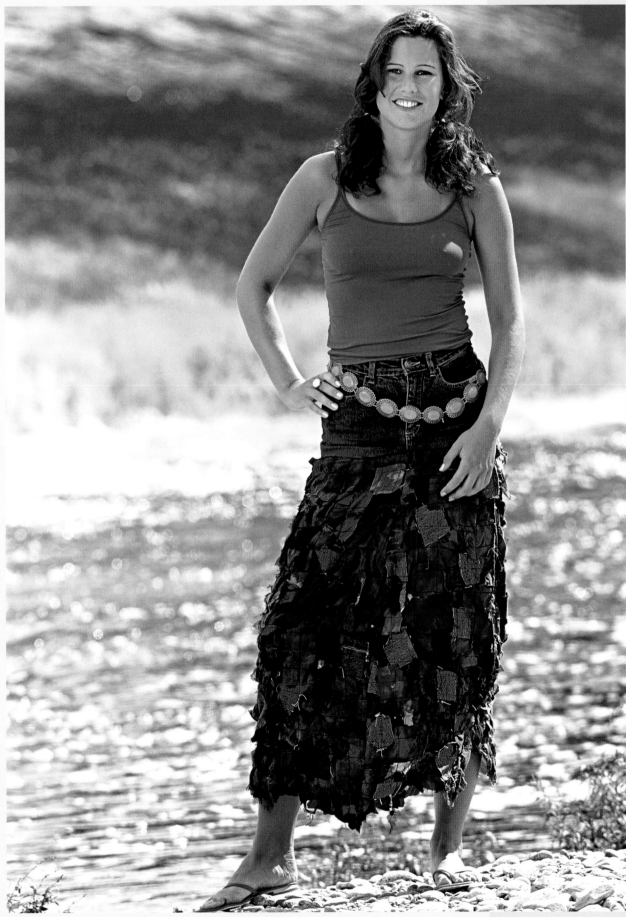

*This wrap is ideal for use on holiday and for any smart occasion.*

## Wrap

**Size:**
Approx. 84 × 84cm (33 × 33in)

**Level of difficulty:**

◆

# Eye-catching – and not just for summer

**You will always be well-dressed with this wrap-top. A blouse or shirt will look just as good underneath as a knitted top or camisole. The broad cut means that it falls in soft folds at the sides and is suitable for any figure. Elegant or casual – you will love this wrap.**

## Wrap

### MATERIALS

- water-soluble stabiliser, e.g. Soluvlies by Freudenberg, 200 × 90cm (78¾ × 35½in)
- water-soluble spray adhesive
- chiffon, 90 × 30cm (35½ × 11¾in)
- pongé 06, 90 × 15cm (35½ × 6in)
- 1 velvet scarf 110 × 30cm (43¼ × 6in)
- 1 devoré scarf 110 × 20cm (43¼ × 7¾in) (e.g. Artys)
- special-effect yarns in white: 10g (¼oz) each of eyelash yarn and ribbon yarn
- sewing thread in white

### INSTRUCTIONS

**1.** For the back piece, cut out four 90 × 50cm (35½ × 19¾in) rectangles from the stabiliser and prepare according to the basic 'Crazy Wool' technique on pages 10–11.

**2.** Place squares of fabric and both of the special-effect yarns in a netlike pattern on to the stabiliser, press down carefully and cover with a second piece of stabiliser. Secure the corners and side edges with pins and machine-stitch over the entire area to form squares, as explained in the basic 'Crazy Wool' technique on pages 10–11.

**3.** For the front piece, fold the remaining two pieces of stabiliser in half. Mark the centre on the upper edge and make another mark 18cm (7½in) from the centre. Make a further mark below at 3cm (1¼in) from the centre of the lower edge. Now cut out this triangle. The wrap now has a shoulder width of approx. 27cm (10¾in), the neckline is 36cm (14¼in) and the total width is 90cm (35½in). Cover and stitch the remaining pieces of stabiliser as for the back piece.

**4.** Place both pieces right sides together (the side where you can see the threads is the outside) and stitch the shoulder seams and the side seams up to approx. 15cm (6in) above the lower edge. Turn the top right side out and rinse out.

### TIP

*You can alter the depth of the neckline according to taste. To ensure that the wrap nature of this garment is retained, the top must fall lightly and away from itself. The cut of this wrap is bound to make it your favourite top – comfortable, light and strikingly pretty with its simple, white and airy appearance. The cut is flexible. For large sizes (such as 18–22), lengthen it by 10cm (4in), leaving the width the same. If the wrap is made in these sizes, the V-neckline can be replaced by a round neckline.*

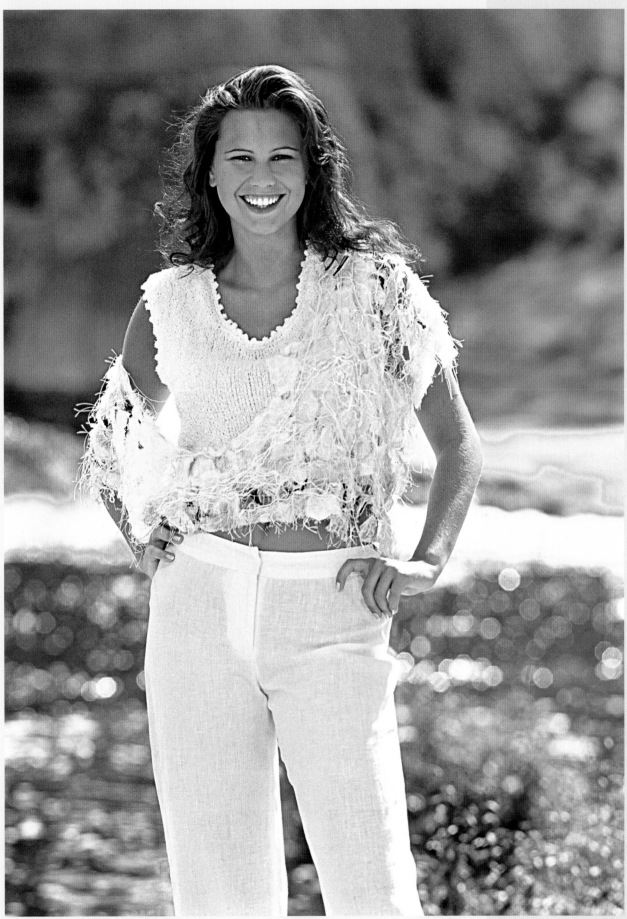

# The perfect complement

**Every wardrobe should contain a wide belt. In the width recommended, this accessory can be worn around the hip or waist, even for fuller figures. The belt can be clipped together with one of your favourite clips.**

*The matching bag for this belt is practical and strikingly pretty*

## Bag
**Size:**
30 × 20cm (11¾ × 7¾in)

**Level of difficulty:**

## Belt
**Size:**
Length 110cm (43¼in)
for dress sizes 10–14

**Level of difficulty:**

## Bag

### MATERIALS

- cotton fabric in dark blue, approx. 110 × 35cm (43¼ × 13¾in)
- iron-on interfacing, e.g. Vlieseline H200 by Freudenberg (to reinforce the flap), 30 × 15cm (11¾ × 6in)
- water-soluble spray adhesive
- soft, printed yarn (100% polyamide) in blue and green, 25g (1oz)
- water-soluble stabiliser, e.g. Soluvlies by Freudenberg, 90 × 60cm (35½ × 23½in)
- sewing thread
- approx. 20 glass beads, diameter 3mm
- hot-glue gun or textile glue

### INSTRUCTIONS

**1.** Cut out two rectangles, each 60 × 25cm (23½ × 9¾in), from the cotton fabric according to the bag pattern.
**2.** On the top third of one of the rectangles, iron on 20cm (7¾in) of interfacing for the flap of the bag and turn the fabric over. Spray adhesive on this upper third of fabric and place yarn in wavy lines on top, preferably overlapping the edge of the fabric. This will give the edge of the bag an irregular and attractive border. Press the yarn down lightly with your palm and spray again with spray adhesive.
**3.** Cut out the stabiliser to the size of the area covered with yarn and cover the area with it. Pin around the edge. Sew over the surface in wavy lines, leaving a distance of approx. 1–2cm (½–¾in) between the lines.
**4.** For the shoulder strap, cut out a strip 90 × 10cm (35½ × 4in), turn in 1cm (½in) at each edge and iron down. Fold in half, spray with adhesive and cover with strips of yarn. Sew with size 2 zigzag stitch.
**5.** Place the second piece of cotton right sides together with the exterior of the bag decorated with yarn; push the strap immediately after the decorated area in between both pieces of fabric and pin. Stitch around with one seam. Fold over the lower third and stitch up the side edges. Turn right side out and rinse out.

**6.** Once the bag is dry, iron flat and stick on the beads (see photograph) using hot glue or textile glue and rinse out.

## Belt

### MATERIALS

- cotton fabric in dark blue, approx. 110 × 35cm (43¼ × 13¾in)
- water-soluble spray adhesive
- soft, printed yarn (100% polyamide) in blue and green, 25g (1oz)
- water-soluble stabiliser, e.g. Soluvlies by Freudenberg, 90 × 60cm (35½ × 23½in)
- sewing thread
- approx. 20 glass beads, diameter 3mm
- hot-glue gun or textile glue

### INSTRUCTIONS

**1.** Cut out the cotton fabric according to the template on page 44 and continue with the basic 'Crazy Wool' technique.
**2.** Machine-stitch the belt in virtually parallel wavy lines 2cm (¾in) apart. Rinse out, leave to dry, iron flat and decorate with beads as for the bag.

### *TIP*

*You can draw the wavy lines on the stabiliser beforehand using a ballpoint pen to make it easier to do the 'Crazy' sewing for the first time. However, do not use a felt-tip pen or permanent ink pen, as they will penetrate the yarn and cannot be rinsed out.*

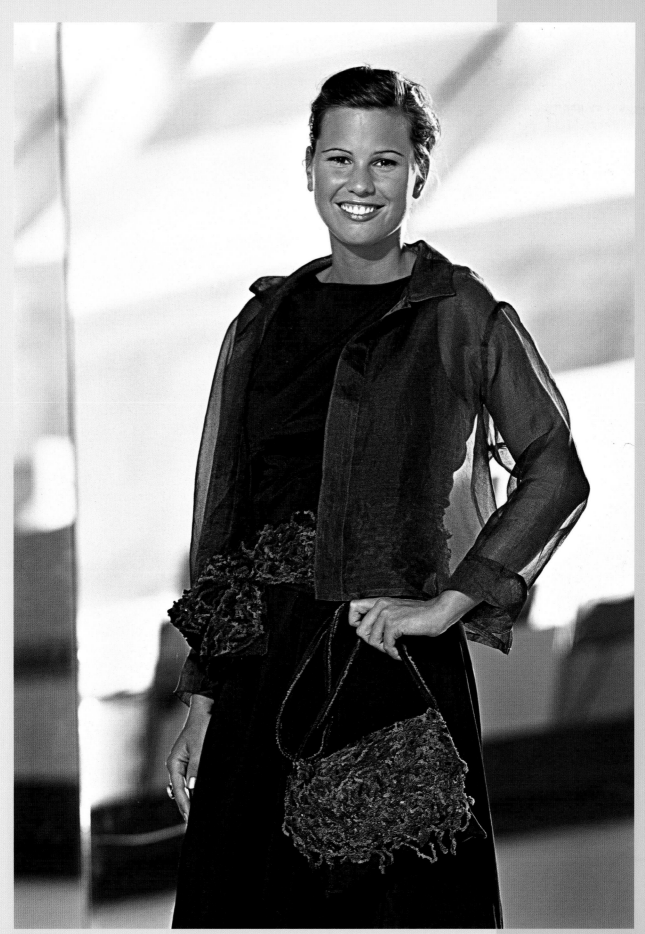

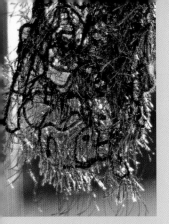

*You can wear this sweater with jeans or a skirt.*

## Sweater
**Size:**
12–16

**Level of difficulty:**

## Scarf
**Size:**
individual

**Level of difficulty:**

# Outdoor sweater and scarf

**A cosy top is useful all year round. This garment shows how easy it is to make a thick sweater by simply sewing several layers of yarn on top of one another. Compared with a knitted garment, you need to calculate just one-third of the wool that would otherwise have been needed to make this lovely, warm sweater.**

## Sweater

### MATERIALS

- water-soluble stabiliser, e.g. Soluvlies by Freudenberg, 220 × 90cm (86½ × 35½in)
- water-soluble spray adhesive
- aran (worsted) yarn (30% linen/70% viscose) in light blue, 150g (5¼oz)
- eyelash yarn in dark blue, 200g (7oz)
- sewing thread in dark blue

### INSTRUCTIONS

**1.** Cut out the stabiliser for the front and back pieces 60 × 55cm (23½ × 21¾in) according to the template on page 42. Cut out the stabiliser for the sleeves four times: lower edge 25cm (9¾in), upper edge 45cm (17¾in), sleeve length 30cm (11¾in) (for short sleeves).
**2.** Starting with the front piece, place a piece of stabiliser on to the work surface and spray with adhesive.
**3.** Place more of the light blue aran yarn pieces at the sides to highlight the front if desired. Try combining the light and dark blue fibres in different ways. You can, for example, place more light blue threads on top in some areas, and the sleeves or hemline can be emphasised in dark blue.
**4.** First cover the whole area of stabiliser, spray with adhesive, then lay the next layer of yarns over randomly, pressing down the threads lightly with your palm and finishing off with a decorative layer (see photograph).
**5.** Complete all the parts for the sweater according to the basic 'Crazy Wool' technique on pages 10–11 and sew together as follows: stitch the front and back pieces at the shoulder seams. Pin the centre top of the sleeve to the shoulder seam, then to the front piece and then pin to the back piece. Sew the seam using the sewing machine and then close up the underneath of the sleeve and the side seam between the front and back pieces. Rinse out. Proceed in the same way for the second sleeve. Rinse out.

## Scarf

### MATERIALS

- water-soluble stabiliser, e.g. Soluvlies by Freudenberg, 180 × 90cm (70¾ × 35½in)
- water-soluble spray adhesive
- aran (worsted) yarn (30% linen/70% viscose) in light blue, 50g (1¾oz)
- eyelash yarn in dark blue, 50g (1¾oz)
- sewing thread in dark blue

### INSTRUCTIONS

**1.** Cut out the stabiliser into four 90 × 45cm (35½ × 17¾in) rectangles and place them on top of one another in pairs.
**2.** Spray adhesive on to the first piece of stabiliser and place the special-effect yarns randomly on to the stabiliser, as in the photograph. Keep spraying with adhesive as you go to secure the threads to the stabiliser.
**3.** Spray again with spray adhesive and then lay on the second layer of stabiliser. Push threads that are hanging over the edge of the stabiliser in between the stabiliser layers before sewing. Top-stitch in either a square pattern or in wavy lines (see page 9). The distances between the lines should be no more than 3–4cm (1¼–1½in).

### *TIP*

*As this outdoor sweater is fairly dense, the matching scarf should be airy and covered with less yarn. For the sweater, the seams will no longer be visible after rinsing out due to the pile of the yarn, whereas for the scarf, these seams come to the fore to form an attractive net effect.*

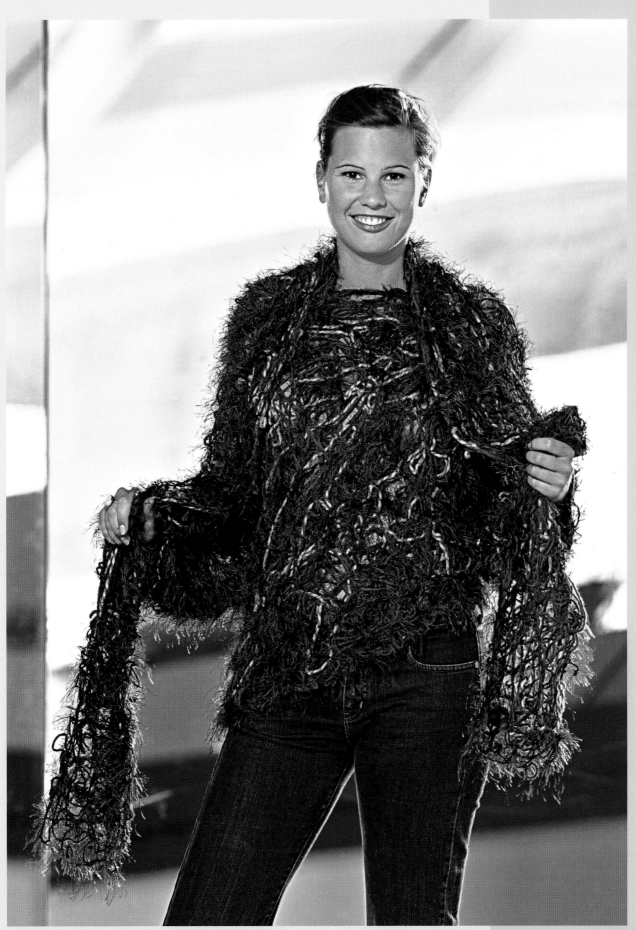

*This sweater is both casual and elegant.*

## Colourful fleecy sweater

**Size:**

12

**Level of difficulty:**

# Colours of summer

This sweater looks really fleecy, yet it is great for warm, summer days, as the colourful threads give it a light feel. It will go well with skirts and trousers in a wide variety of colours.

## Colourful fleecy sweater

### MATERIALS

- water-soluble stabiliser, e.g. Soluvlies by Freudenberg, 180 × 90cm (70¾ × 35½in)
- multicoloured eyelash yarn: 50g (1¾oz) each in blue/green/lilac, mid-blue/red/green, red/green/yellow and red/turquoise/yellow
- water-soluble spray adhesive
- sewing thread in blue or green

### INSTRUCTIONS

**1.** For the front and back pieces, cut out four 50 × 50cm (19¾ × 19¾in) squares from the stabiliser, and for the sleeves cut four 25 × 40 × 45cm (9¾ × 15¾ × 17¾in) pieces and prepare them according to the basic 'Crazy Wool' technique on pages 10–11. This sweater is made without cutting out the neckline.

**2.** Place the eyelash yarns crossways from one side edge to the other. Lay the colours given above in approx. 10–12cm (4–4¾in) stripes working from the lower edge of the top upwards row by row.

**3.** For the slight neckline in the front piece, push under the threads laid in the centre by approx. 3cm (1¼in) and spray this part again with spray adhesive. Using the darkest yarn, place three to four threads around the neckline. Press down lightly and place the second stabiliser layer on top.

**4.** Proceed in the same way for the back piece, which does not have a neckline, and for both sleeves. Top-stitch from top to bottom, as the laid threads run crossways. The distance between the individual lines of stitching is approx. 3cm (1¼in).

**5.** Before the parts are sewn together right sides facing, draw a mark on the right side of the stabiliser with a ballpoint pen, so that after turning you will know that the correct side is outside.

**6.** Now first close up the shoulder seams, then pin the first sleeve at the top in the centre to the shoulder seam. Pin the sleeve to the front first and then to the back. Sew up the seam with the sewing machine and then sew the underneath of the sleeve from the wrist upwards, then sew up the side seam between the front and back pieces. Proceed in the same way for the second sleeve. Turn the garment right side out and rinse out.

### TIP

*We recommend that you handwash this soft, pile yarn to remove the stabiliser. Then lay the sweater on a towel, so that it will dry quickly and hold its shape.*

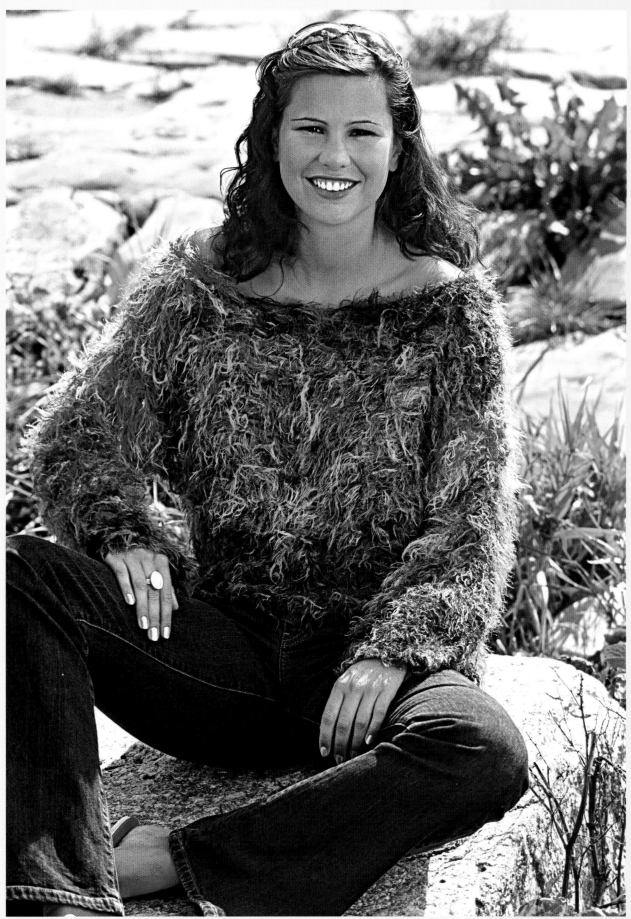

*Sheer elegance – the 'Queen of the Night'.*

Skirt
Size:
10–14
Level of difficulty:

Stole
Size:
200 × 60cm (78¾ × 23½in)
Level of difficulty:

Sequin top
Size:
individual
Level of difficulty:

# Evening colours

**You will sparkle at any special occasion in this three-piece outfit. The top is made from stretchy, sequined fabric and the skirt has an elasticated waist, allowing plenty of room for gaining or losing weight. They can be altered according to size. The sequin top can easily be worn independently from the skirt and stole with white, summer trousers or jeans for a garden party.**

## Skirt

### MATERIALS

- organza in black, 240 × 120cm (95½ × 47¼in)
- pongé 06, 120 × 120cm (47¼ × 47¼in), dyed blue
- pongé 06, 120 × 120cm (47¼ × 47¼in), dyed dark green
- devoré, 120 × 120cm (47¼ × 47¼in), dyed blue
- devoré, 90 × 60cm (35½ × 23½in), dyed dark blue (after dyeing, appears royal blue)
- silk dye, e.g. Marabu SilkArt, in sapphire, dark green and black
- water-soluble stabiliser, e.g. Soluvlies by Freudenberg, 450 × 90cm (177¼ × 35½in)
- 2 rolls of sewing thread in black, each 500m (dyeing instructions on page 7)
- elasticated waistband, 30mm (¼in), 90cm (35½in) long

### INSTRUCTIONS

**1.** Dye the fabric according to the dyeing instructions on page 7, as indicated above.
**2.** Cut out four skirt panels from organza and stabiliser: length approx. 112 cm (44in), width approx. 300 cm (118in). Then first sew the organza underskirt by top-stitching the side seams.
**3.** Spray the stabiliser panels with spray adhesive and continue following the basic technique on pages 8–9.
**4.** Place the underskirt and 'rag skirt' right sides together and stitch together along the waist seam. Pin the elasticated waistband along the waist and top-stitch. Rinse out.

## Stole

### MATERIALS

- organza in black, 200 × 120cm (78¾ × 47¼in)
- water-soluble stabiliser, e.g. Soluvlies by Freudenberg, 55 × 55cm (21¾ × 21¾in)
- water-soluble spray adhesive

### INSTRUCTIONS

**1.** Fold the organza fabric in half and pin along one of the short sides. Divide the stabiliser into two triangles, cover one with the remaining squares from the skirt using the 'Crazy Patchwork' technique (see pages 8–9) and complete. Spray again and cover with the second stabiliser triangle.
**2.** Stitch the stabiliser triangle (with silk squares) to the end of the organza stole and then rinse out.

## Sequin top

### MATERIALS

- sequin fabric, 90 × 45cm (35½ × 17¾in) (bust measurement plus 2cm (¾in) seam allowance)
- sewing thread

### INSTRUCTIONS

Fold the sequin fabric in half (45 × 45cm) (17¾ × 17¾in) and stitch the lengthways seam to form a tube.

### *TIP*

*If, having made the stole, there are still 12–15 fabric squares remaining, you can place them on approx. 20 × 20cm (7¾ × 7¾in) of stabiliser in a circular flower shape and sew on. Rinse out the piece and sew the flower that remains on to the top by hand. The organza skirt can be turned up approx. 1cm (½in) at the hemline and neatened off (stitched).*

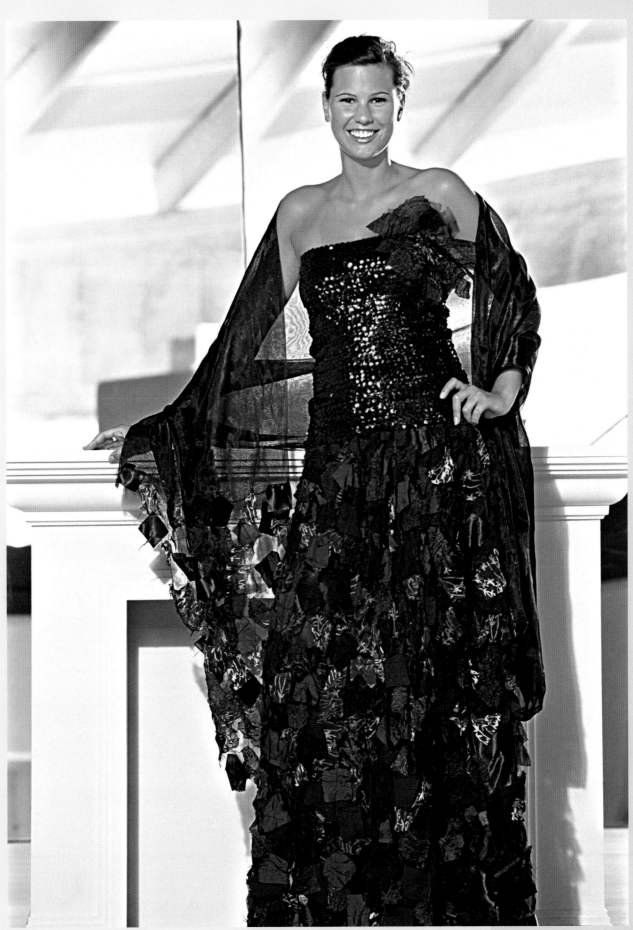

## Top (see page 12)
### Size 10–12

Back piece
55 × 55cm
(21¾ × 21¾in)

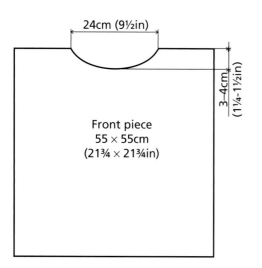

24cm (9½in)

3–4cm
(1¼–1½in)

Front piece
55 × 55cm
(21¾ × 21¾in)

## Sweater (e.g. see page 14)
### Size 12–14

1 x back piece
1 x front piece with neckline
W55 × L60cm
(W21¾ × L23½in)

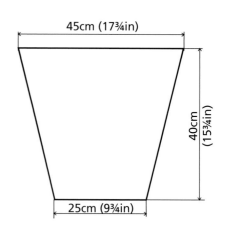

45cm (17¾in)

40cm
(15¾in)

25cm (9¾in)

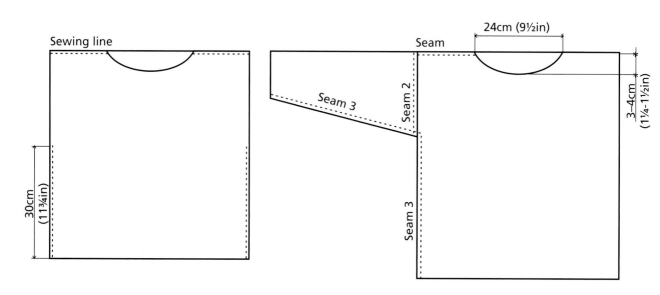

Sewing line

30cm
(11¾in)

Seam

24cm (9½in)

Seam 2

Seam 3

Seam 3

3–4cm
(1¼–1½in)

# Casual bag (see page 16)

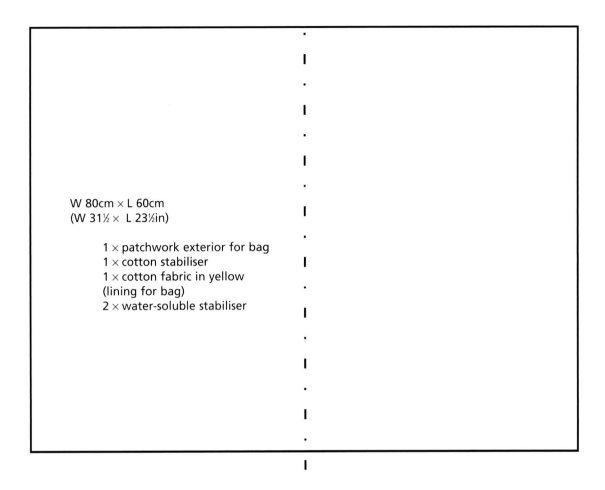

W 80cm × L 60cm
(W 31½ × L 23½in)

1 × patchwork exterior for bag
1 × cotton stabiliser
1 × cotton fabric in yellow
(lining for bag)
2 × water-soluble stabiliser

Shoulder strap

Sewing line (right sides together)

A    W 100cm × L 10cm         2 × towelling                    B
     (W 39¼ × L 4in)          2 × cotton fabric in yellow

Sewing line (right sides together)

A                    B

Front piece
Back piece

## Fabric and raffia bag (see page 22)

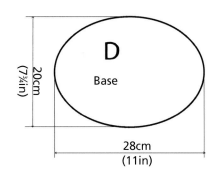

D

Base

20cm
(7¾in)

28cm
(11in)

W 80cm × L 40cm
(W 31½ × L 15¾in)

1 × fabric/raffia exterior for bag
1 × cotton fabric lining for bag
2 × water-soluble stabiliser

### Shoulder strap

2 × fabric orange/red

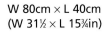

| A | W 80cm × L 6cm (W 31½ × L 2¼in) | B |

W 80cm × L 3cm (W 31½ × L 1¼in)

2 × pelmet interfacing

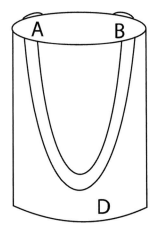

A    B

D

## Belt (see page 34)

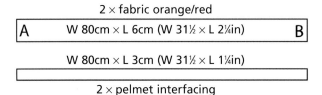

W 110cm × L 30cm
(W 43¼ × L 12¼in)

1 × cotton fabric
1 × water-soluble stabiliser

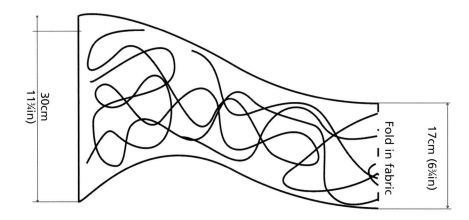

30cm
11¾in

17cm (6¾in)

Fold in fabric

# Vlieseline®
## New vlieseline® Soluvlies

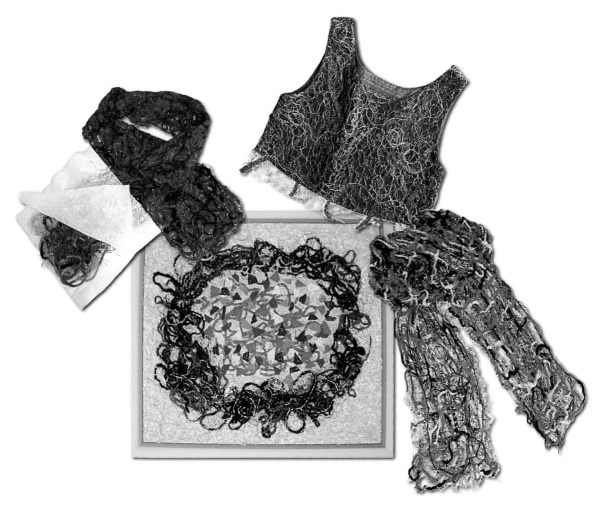

## Dissolves in cold water
## Stabiliser for handicrafts and embroidery

- Washes out in cold water
- Ideal stabiliser
- Suitable for very fine fabrics, freehand lace embroidery, appliqué and inset motifs
- Collages using special thread techniques
- Ideal aid when sewing mini-quilts

Freudenberg Vliesstoffe KG
Vertrieb Vlieseline
Hatschekstraße 11
69126 Heidelberg / Germany
www.vlieseline.de

# Acknowledgements

The author would like to thank the following
companies for their support:
Freudenberg, Heidelberg;
Zweigart & Sawitzki, Sindelfingen;
Brother International GmbH, Bad Vilbel;
Coats GmbH, Kenzingen;
Marabuwerke GmbH & Co., Tamm;
Prym, Stolberg

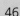

First published in Great Britain 2009 by
Search Press Limited, Wellwood, North Farm
Road, Tunbridge Wells, Kent TN2 3DR

Originally published in Germany 2005 by
OZ-Verlags-GmbH

English translation by Cicero Translations

English edition edited and typeset by
GreenGate Publishing Services, Tonbridge, Kent

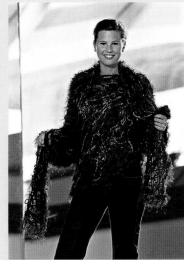

ISBN: 978–1–84448–432–4

## Suppliers

If you have difficulty in obtaining any of the
materials and equipment mentioned in this
book, then please visit the Search Press
website for details of suppliers:
www.searchpress.com

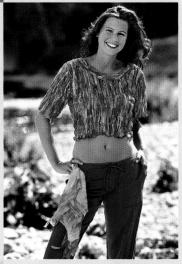

## Designs and production:
Jeannette Knake

## Photography:
Hermann Mareth (pages 13–41)
Frank Rabis (pages 6, 8–11)
Marabuwerke GmbH & Co. (page 7)

## Styling:
Betina Pohl

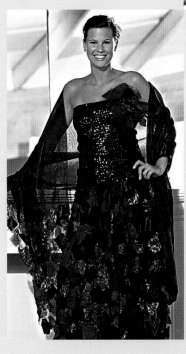

## Technical drawings:
Frank Rabis

## Layout:
Dieter Richert, www.designreporter.com

## Printed in Malaysia

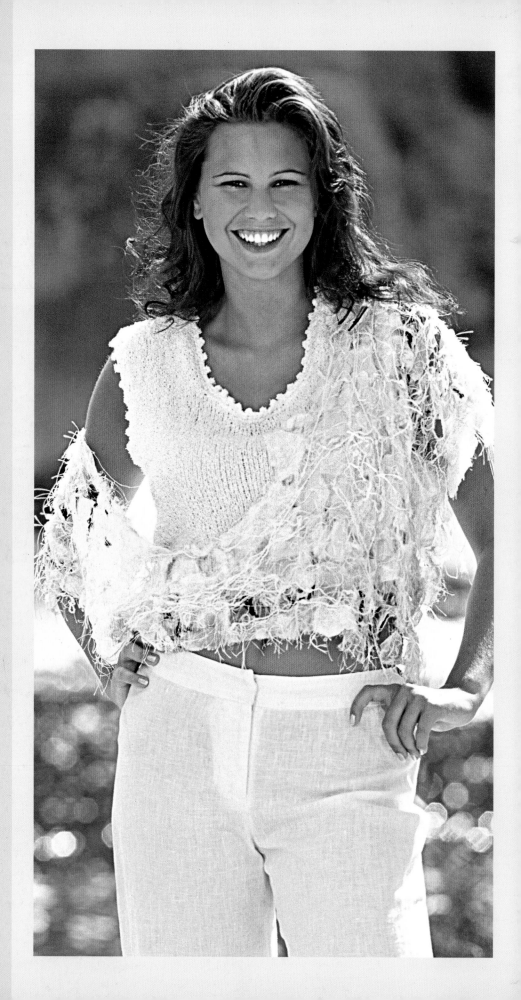